Rembrandt

THE LIFE AND WORKS OF

REMBRANDT

Douglas Mannering

A Compilation of Works from the
BRIDGEMAN ART LIBRARY

PARRAGON

Rembrandt

This edition first published in Great Britain in 1994
by Parragon Book Service Limited

© 1994 Parragon Book Service Limited

ISBN 1 85813 595 8

Printed in Italy

Editorial Director: Lesley McOwan
Designer: Robert Mathias
Production Director: David Manson

REMBRANDT VAN RIJN 1606-1669

REMBRANDT IS ONE OF the towering figures in the history of European art; many would call him the greatest of all painters. He worked within the superficially restricted tradition of Dutch Protestant art and never left his native land. Yet he was not only technically brilliant as a painter but showed a new kind of insight: no one before Rembrandt made the ordinary stuff of humanity seem so deeply serious and interesting. In his scenes from history and Biblical episodes, as in his portraits of rich and poor contemporaries, Rembrandt seems to go straight to the heart. His perceptiveness may well have been based on self-knowledge, for he painted his own image again and again, making a unique record of a pilgrimage from youth and success to old age and loss.

Rembrandt Harmensz van Rijn was born on 15 July 1606 in the Dutch city of Leyden. His father was a miller, evidently prosperous enough to give his oldest son a sound education and enrol him at the University of Leyden (1620). But Rembrandt must have chosen to become an artist almost immediately, for he served a three-year apprenticeship with a local painter and then, in 1624, spent six months as a student with Pieter Lastman in Amsterdam. Lastman was a skilful, Italian-trained artist who introduced Rembrandt to chiaroscuro, the use of light and shadow to model forms and produce dramatic effects; the technique was to be central to his art.

For the next few years Rembrandt worked in his home town, making his reputation as a painter of Biblical and mythological set-pieces. In 1631 or early 1632 he moved to Amsterdam, where he made an immediate success with *The Anatomy Lesson of Dr Tulp* (page 10). Rembrandt lodged with the art dealer Hendrick van Uylenburgh, who became his partner and helped to provide the many portrait commissions which made him a fashionable and well-off young artist.

In 1634 Rembrandt made a good match by marrying his partner's niece, Saskia van Uylenburgh, and by 1639 the couple were able to buy a fine town house of their own. Three of Rembrandt's children died in infancy, and although a son, Titus, was born in 1641 and survived, Saskia herself died the following year. Yet this was also when Rembrandt painted the most celebrated of all his works, *The Night Watch* (page 33), and reached the summit of his public success.

Rembrandt's private life now became tangled, although the evidence is tantalizingly difficult to interpret. In 1642 the painter employed a widow, Geertge Dircx, to look after Titus. In 1649 she sued him for breach of promise, successfully. A year later she was in a house of correction, maintained at Rembrandt's expense; whether he was being generous or, quite the contrary, had selfishly had her put away, we have no means of knowing.

One of the witnesses during the legal wrangling was a young servant, Hendrickje Stoffels, who entered Rembrandt's household around 1647. She may well have been the cause of his break with Geertge Dircx; at any rate she remained the painter's housekeeper and mistress until her death in 1663. The face that appears in *Bathsheba* (page 47) and so many other famous, tenderly executed

paintings of the 1650s must be hers, and there is reason to suppose that she was Rembrandt's trusted and faithful companion. In 1654 she became pregnant and was hauled before the local Reformed Church and rebuked; but after that the matter seems to have been dropped. In October 1654 Hendrickje bore Rembrandt a daughter, Cornelia.

In the early 1650s Rembrandt painted one masterpiece after another. He was no longer a fashionable success, but never lacked wealthy customers. So it was probably mismanagement that brought about his bankruptcy in 1656, culminating in the sale of his house in 1660. Titus and Hendrickje formed a partnership to employ Rembrandt – so that 'their' paintings would not fall into his creditors' hands – and the household moved to the outskirts of Amsterdam.

After this, Rembrandt's life was outwardly undramatic. He outlived both Hendrickje and Titus, dying on 8 October 1669.

Detail

▷ **Two Old Men Disputing** c.1628

Oil on panel

THIS WAS PAINTED in the years when the young Rembrandt was making his reputation in his home town of Leyden. It is very small and highly finished, one of many examples that seem to have been executed to satisfy a special local taste. The old men have been variously described as philosophers and scholars, a plausible interpretation in view of the books and papers that are scattered about. An alternative theory, much favoured in recent years, is that the men are the Apostles St Peter and St Paul; other painters would signal the fact by including obvious pointers such as St Peter's keys (the keys to heaven), but Rembrandt tended to avoid symbols when they detracted from the reality of a scene. If this interpretation is correct, St Paul is expounding a passage from Scripture, his finger on the page of a book which St Peter is holding. This fits in with the known dispute between the two, effectively won by Paul, over whether Christianity should be preached to the Gentiles.

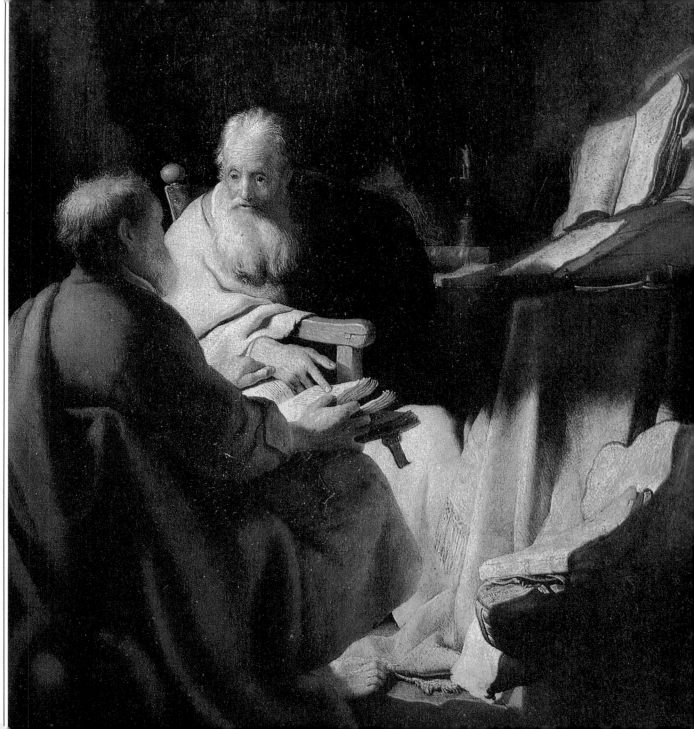

▷ **The Anatomy Lesson of Dr Tulp** 1632

Oil on canvas

REMBRANDT BASED this painting on a lecture given in Amsterdam by Dr Nicholas Tulp in January 1632. Although the artist had not long before arrived in the city from Leyden, he had already proved his ability by painting a couple of portraits, and had impressed enough to win the commission for *The Anatomy Lesson*. The connections of Hendrick van Uylenburgh, the dealer with whom Rembrandt lodged, may well have decided the matter; Uylenburgh had built up his business by patronizing and marketing promising young artists, and Rembrandt was his latest protégé. The group portrait was a Dutch speciality, and this one was intended as a tribute to Tulp by his colleagues – who, however, expected to feature prominently in the picture. Rembrandt succeeded brilliantly in portraying them as individuals, while unifying the composition by making them peer with professional interest at the cadaver (an executed criminal) as Tulp discourses. The painting established Rembrandt's reputation overnight.

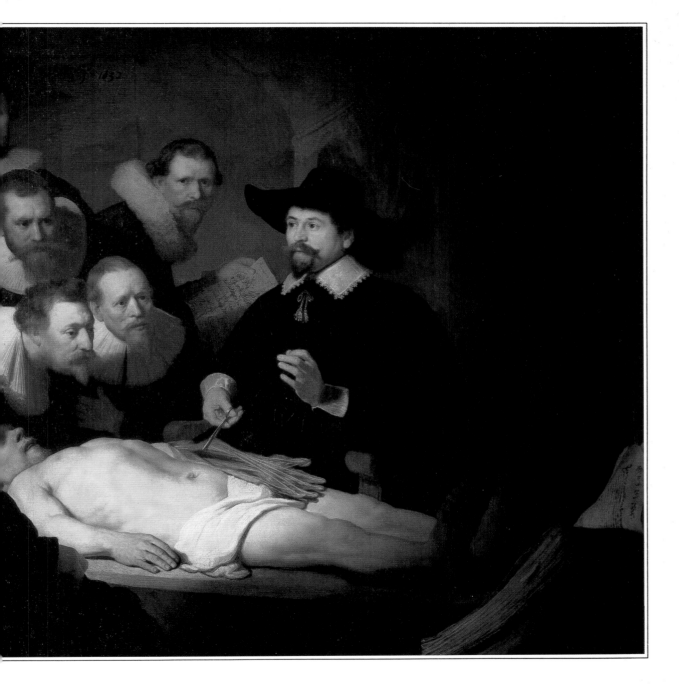

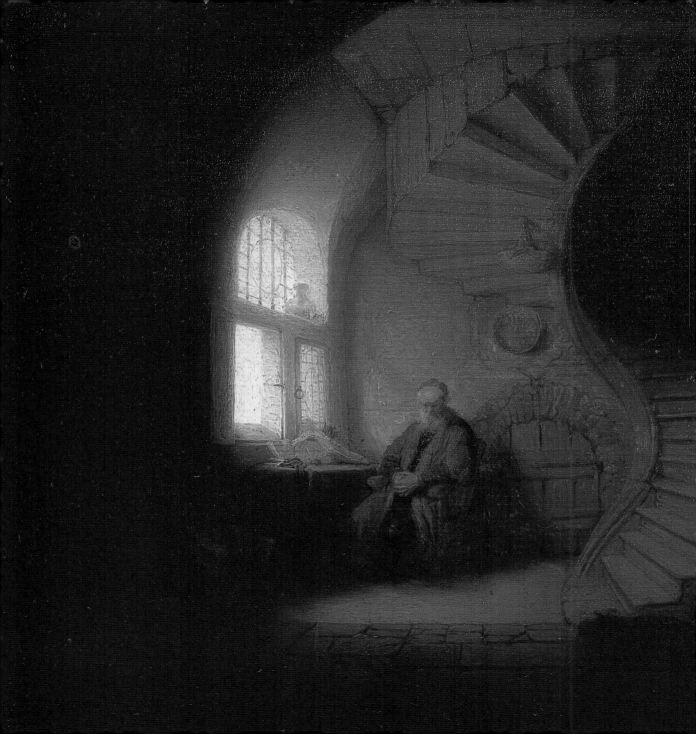

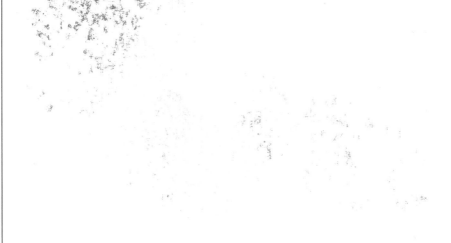

◁ **A Scholar in a Room with a Winding Staircase** 1632

Oil on panel

REMBRANDT WAS ESTABLISHED in Amsterdam by the time this was painted, but it is something of a throwback to his Leyden period in its subject and small size. As on page 8, the main figure has been variously described as a philosopher or a scholar; a religious intention seems less likely here. Thinkers poring over books seem to have fascinated Rembrandt, for he returned to the subject several times over the years; a life devoted to study, reflection and work may have seemed particularly attractive in the 1630s by contrast with his own laborious but necessarily social existence as an artist much in demand. Diligent Rembrandt scholars have shown that the painter took the winding staircase directly from a book on perspective by a fellow artist. It is used to great compositional effect, its bottom curve enclosing and focusing the attention on the meditative scholar, whose stillness contrasts sharply with the eagerness of the figure poking the fire.

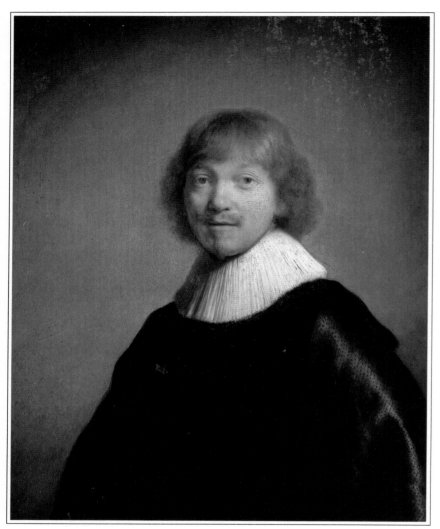

◁ **Portrait of Jacques de Gheyn III** 1632

Oil on panel

JACQUES DE GHEYN III was himself an artist but, as one of his friends lamented, an inheritance had blunted his ambition and he failed to fulfil his promise. However, he did become Rembrandt's patron, buying *Two Old Men Disputing* (page 8) as well as sitting for this portrait. It is one of a pair which de Gheyn and his close friend Maurits Huygens, a civil servant, commissioned Rembrandt to paint, probably at The Hague. The friends agreed that whoever died first should leave his portrait to the other; and in 1641, on de Gheyn's death, this painting duly passed to Huygens. It is a kindly, sympathetic work, showing de Gheyn as rather worn-looking; the soft light moulds the forms pleasantly and picks out the texture of the sitter's ruff and coat. Nevertheless, another of Rembrandt's patrons, Maurits Huygens's brother Constantijn, wrote no less than eight verses complaining that the portrait was absolutely nothing like de Gheyn!

▷ **Self-portrait** 1633

Oil on panel

BY 1633 REMBRANDT had
already painted several self-
portraits; and there were
many more to come. No
previous artist had engaged in
this lifelong self-scrutiny,
which constituted a prolonged
meditation on ageing,
experience, success and
failure. Here the emphasis
seems to be on success, with
the fashionable young artist
dressed in black velvet and
fingering a gold chain with his
elegantly gloved hand. Yet this
is hardly a celebration of
affluence and self-confidence:
Rembrandt's gaze already
questions the enigma of
existence, and the twenty-
seven-year-old is visibly the
same man as the defiant artist
of fifty-five (page 66) and the
storm-battered old man of
sixty-three, close to the end
(page 77). The spiritual
kinship of Rembrandt's
self-portraits is all the more
striking when it is
remembered that in this one
he is still advancing and on the
verge of marriage, unaware of
the setbacks that were in store
for him.

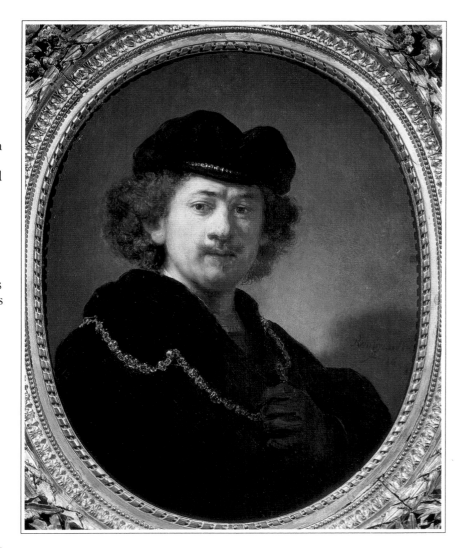

▷ The Incredulity of St Thomas 1634

Oil on panel

ST THOMAS WAS ONE of the twelve disciples of Jesus, mentioned several times in the New Testament. Rembrandt portrays a famous episode narrated in The Gospel According to St John. After the crucifixion, Jesus appeared to the disciples, showing them the wounds in his hands and his side. Thomas was not present, and when the others told him what they had seen, he refused to believe them, declaring 'Unless I see in his hands the imprint of the nails, and put my finger in the place, and put my hand in his side, I will not believe.' Eight days later, according to St John, Jesus reappeared among the disciples and commanded Thomas to feel and touch his wounds. Overcome, Thomas then recognized Jesus as his Lord and God. Rembrandt has portrayed the episode as a night scene, so that Jesus's radiance seems like the sole source of light, while Thomas, his incredulity vanquished, shies away.

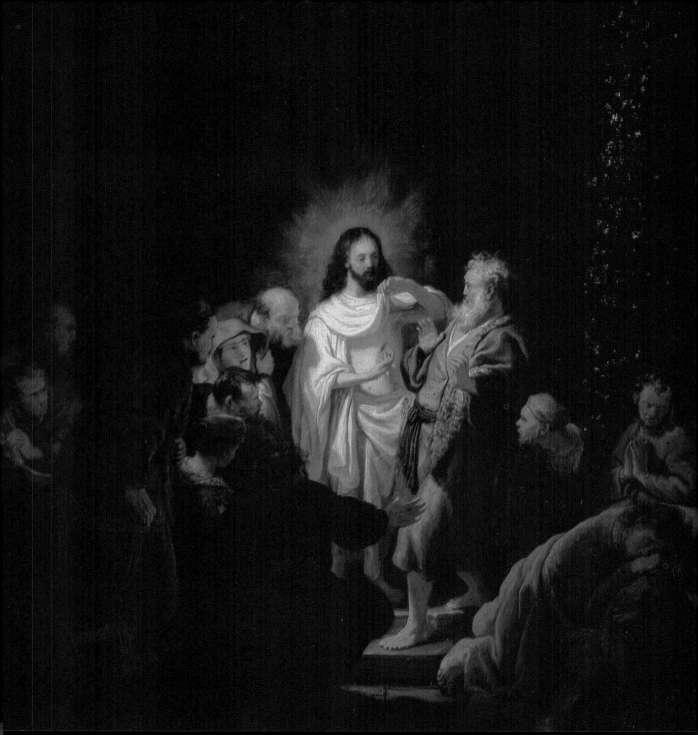

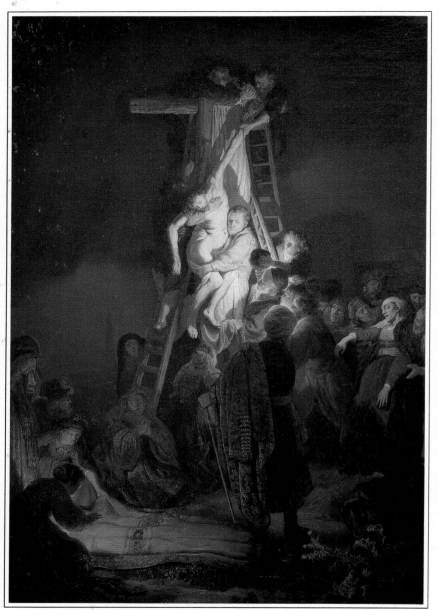

◁ **The Descent from the Cross** 1634

Oil on canvas

THE DESCENT FROM THE CROSS, or Deposition, has often been painted. It is the moment when Jesus's body is taken down from the cross; among those traditionally shown as present are the Virgin Mary, several of the disciples, and the wealthy Joseph of Arimathea. Rembrandt painted a number of Passion scenes in the 1630s, including a *Raising of the Cross* and a *Descent from the Cross* for Frederik Hendrik, the Dutch Stadtholder (hereditary military leader). This is a larger, richer version of the Descent, painted only months later, which Rembrandt kept by him until he was bankrupted in 1656. An intense light falls on the broken figure of Christ and his mother Mary has fainted away; on the ground, laid out in readiness, are the sumptuous linen sheets in which he will lie until he rises again.

▷ **Saskia as Flora** 1634

Oil on canvas

THIS CHARMING PORTRAIT of
the young Saskia van
Uylenburgh was painted in the
year she married Rembrandt.
The girl's reflective but
apparently happy mood is
certainly consistent with the
feelings of a bride. Saskia's
floral headdress and flower-
entwined staff make it natural
to identify the subject as Flora,
the ancient Roman goddess of
spring. The painting of the
goddess's costume is a
technical *tour de force,* but the
real magnitude of
Rembrandt's gifts is revealed
by the air of tenderness he has
imparted to her face. In the
following year he again
painted Saskia as Flora. This
too is a celebrated work,
although X-rays show that he
originally intended it to be a
portrait of the Biblical heroine
Judith, with the severed head
of her people's enemy,
Holofernes, in her lap!

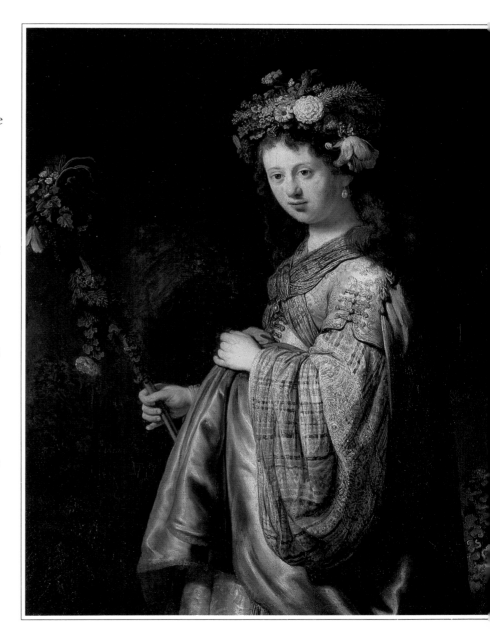

▷ Sophonisba Receiving the Poisoned Cup 1634

Oil on canvas

THE QUEENLY FIGURE in this painting closely resembles Rembrandt's Saskia, although the story of Sophonisba was not entirely appropriate to a newly-wedded wife. Sophonisba was the daughter of the Carthaginian general Hasdrubal, at a time when Carthage was locked in a life-or-death struggle with Rome. To secure an alliance with the Numidians, Hasdrubal married her to King Siphax; but he was defeated by a Numidian rival and Roman ally, Massinissa – who promptly decided to marry her himself. When the Romans vetoed the match, he spared her from further humiliations by sending her a cup of poison which she drank off without hesitation. Rembrandt did not necessarily take this extravagantly romantic tale very seriously, but the painting does evoke a moment of reflection and decision, in some ways comparable to the more celebrated and less theatrical *Bathsheba* (page 47).

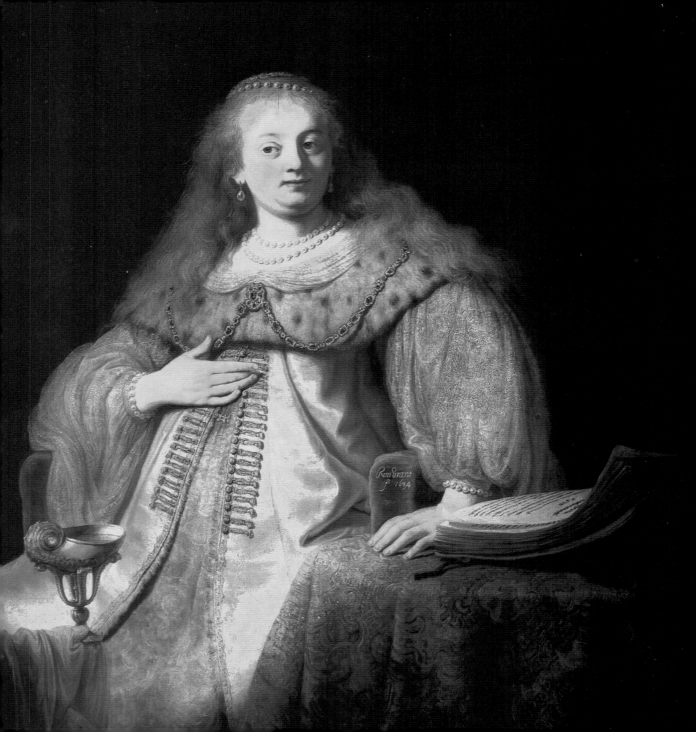

▷ **Belshazzar's Feast** c.1635

Oil on canvas

BIG, SHOWY HISTORICAL paintings were popular in the Netherlands during Rembrandt's lifetime, and *Belshazzar's Feast* demonstrates just how well he could tackle subjects of this kind. Belshazzar was the king of Babylon described in the Old Testament Book of Daniel. At a great feast he sent for the gold and silver vessels which his father, Nebuchadnezzar, had looted from the Temple in Jerusalem, and ordered them to be filled with wine for his lords, wives and concubines. When this sacrilege was carried out, a disembodied hand appeared, and its fingers wrote the mysterious words 'Mene mene tekel upharsin' on the wall. The prophet Daniel told the king they signified his downfall, which occurred the same night. Rembrandt's painting is a study in surprise and fear, emphasized by the ejection of the wine from the sacred vessels, which is also a symbolic event. Unusually, the message is shown in Hebrew letters, and their idiosyncratic arrangement has been traced to Menasseh ben Israel, a Jewish neighbour with whom Rembrandt is known to have been in contact.

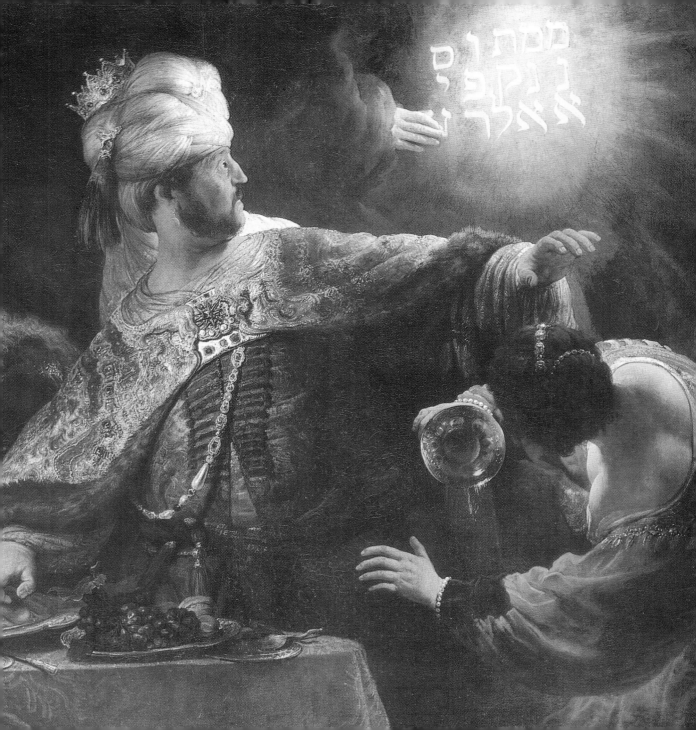

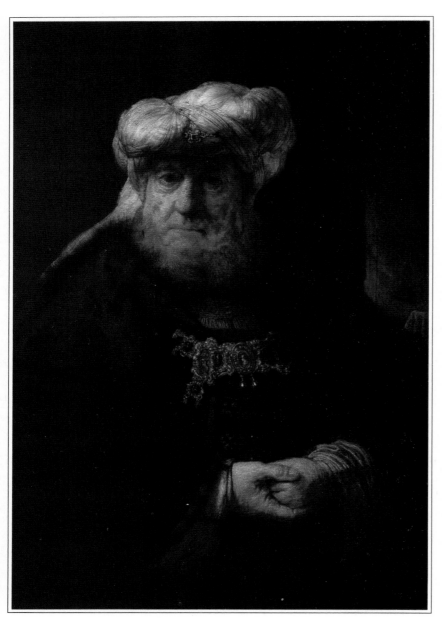

◁ **King Uzziah Stricken with Leprosy** 1635

Oil on panel

THIS IS ALSO SOMETIMES known as *Head of an Oriental;* but there are strong reasons for identifying the subject as Uzziah, a king of Judah whose vanity became so great that he put on priestly robes and sacrificed incense on the altar of the Temple at Jerusalem. He was instantly punished when an earthquake rent the roof of the Temple and a divinely directed ray smote him with leprosy. The powerful inner tension of Rembrandt's Uzziah is expressed in his heavy features and, even more forcefully, through his tightly clasped hands. The grey spots on his face make his leprous condition unmistakable: at a time when Amsterdam was afflicted with the plague, the portrait had a topical relevance. The significance of the brass or gold object behind Uzziah is obscure, though the serpent twined round it may well refer to the plagues of Egypt.

▷ **The Angel Stopping Abraham from Sacrificing Isaac to God** 1635

Oil on canvas

THIS IS ONE OF THE MOST dramatic moments in the Old Testament. The patriarch Abraham, commanded by God to offer his only son, Isaac, as a burnt offering, has taken the boy to a remote place, bound him, and is about to slay him with a knife. In Rembrandt's painting the body actually rests against the wood for the sacrificial pyre. In the Biblical narrative, the Angel of the Lord calls out to Abraham, who has passed the test of obedience to God's will, telling him to stop. Rembrandt heightens the drama by making the angel grasp the patriarch's wrist so that he drops the knife. The scene gains in conviction from the way in which Abraham's large hand covers his son's face, pushing back his head so that his throat is ready for the knife. There is another version of the subject, perhaps only partly by Rembrandt, in Munich.

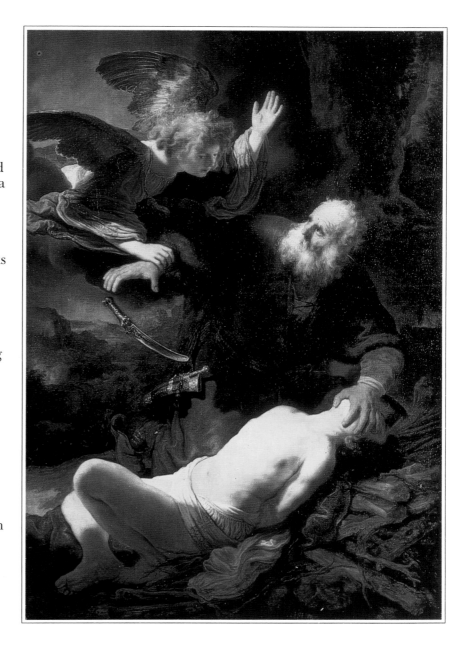

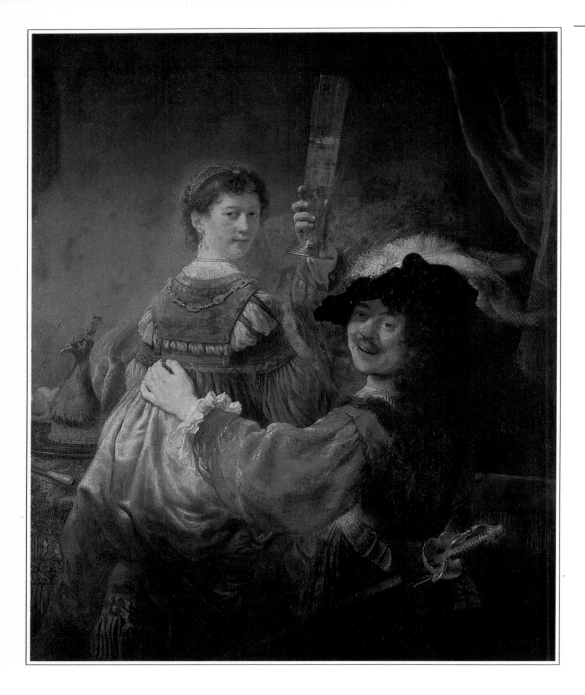

◁ **Self-portrait with Saskia** 1635-6

Oil on canvas

A GAY CAVALIER with a girl on his knee, a glass in his hand and peacock pie on the festive board: they have had their backs to us, but now turn to toast us. Surprisingly, almost nothing is known for certain about this work except that Rembrandt painted it, and that he kept it by him rather than sell it. One reason could be that it had a private meaning for him. The picture has often been described as a self-portrait of Rembrandt with his wife Saskia, and if so they may be dressing up for fun, perhaps taking off the current fashion for scenes with courtesans, or perhaps glorying in their prosperity. However, another interpretation is that the picture represents the Prodigal Son of the parable, wasting his inheritance; if so, we could hardly guess the end of the story (page 74) from this merry scene.

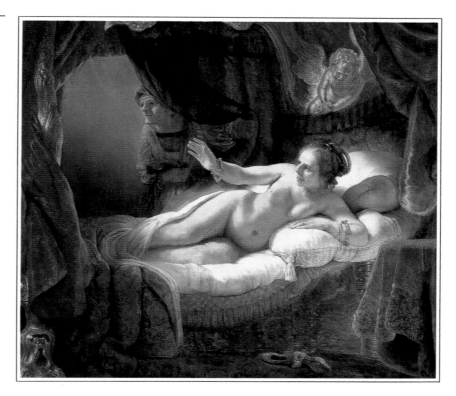

△ **Danaë** 1636

Oil on canvas

THIS IS A PAINTING of extraordinary richness and sensuality, in which the soft, glowing draperies and shining metalwork cocoon the naked figure on the bed. The most commonly accepted title of the work is *Danaë* which would make the subject a maiden, locked up in a tower by her father but seduced by the Greek god Zeus in the form of a shower of gold. What does seem certain is that an unseen lover is approaching, to the bemusement of a servant, and that the woman is inviting him to join her. Above her, a golden, manacled cherub looks on, distraught; but we are never likely to know why.

▷ **The Labourers in the Vineyard** 1637

Oil on panel

REMBRANDT'S PAINTING illustrates one of Jesus's parables. In it, he compared the kingdom of heaven to a householder who went out early in the morning to hire labourers for his vineyard, promising them a denarius for a day's work. At various times in the day he went out again and hired unemployed labourers, telling them he would pay whatever was right. At the end of the day the householder instructed his steward to pay the men, beginning with the last-comers.

They received a denarius, as did all the labourers, including those who had toiled all day in the sun. When these men grumbled, the householder reminded them of their agreement and rebuked them, for 'the last shall be first, and the first last', a statement implying that even the latest comer among believers would be saved. Though gloriously rich-toned, Rembrandt's painting is not a finished work, and seems to have been kept for use as a model by other painters in his ambit.

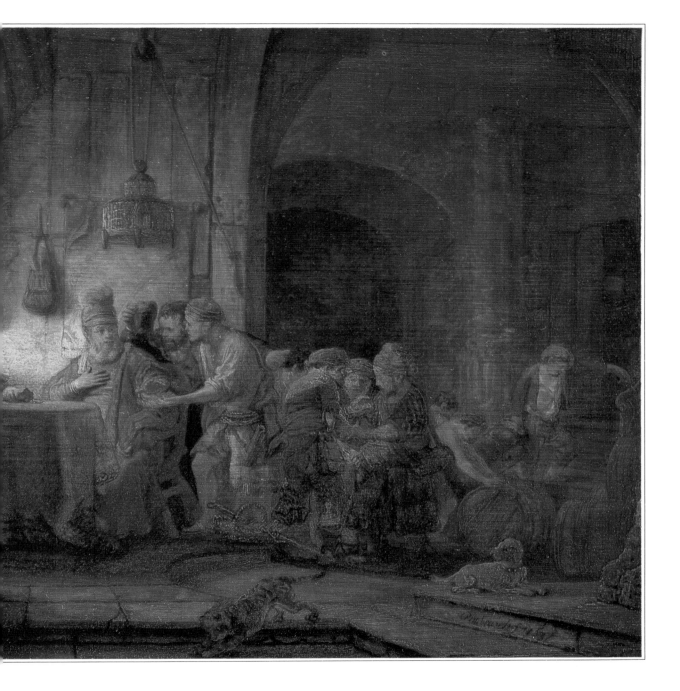

▷ **The Entombment** c.1639

Oil on panel

THIS IS AN OIL SKETCH of the placing of Christ in his tomb following the crucifixion: the occasion is one of deep sorrow, since none of the mourners can know that the dead man will soon rise again, leaving the tomb empty. The swift, free manner in which Rembrandt has sketched out the scene, the contrasts of light and shade, and variety of the mourners' poses are typical of the artist's gifts for drawing and etching, media with which this work has much in common. Its practical purpose is unclear, since there was no question in the 17th century of finding a buyer for a work so lacking in finish. It may have been a preparatory sketch for a painting of the Entombment which Rembrandt executed as one of a Passion series for the Stadholder Frederik Hendrik (see page 18), although it differs from the finished painting in many important respects.

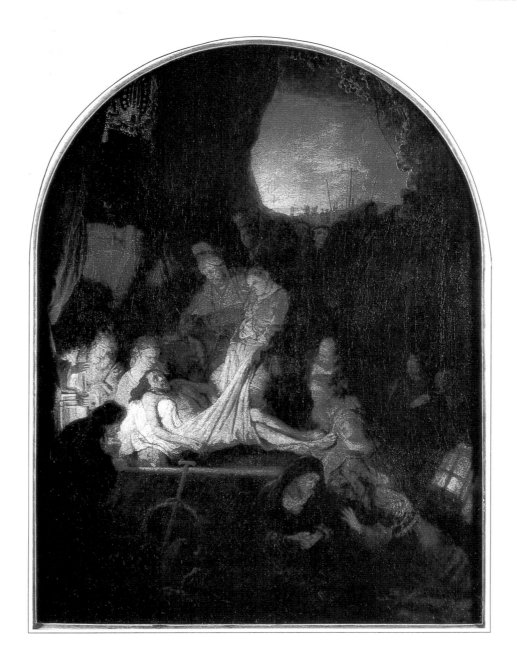

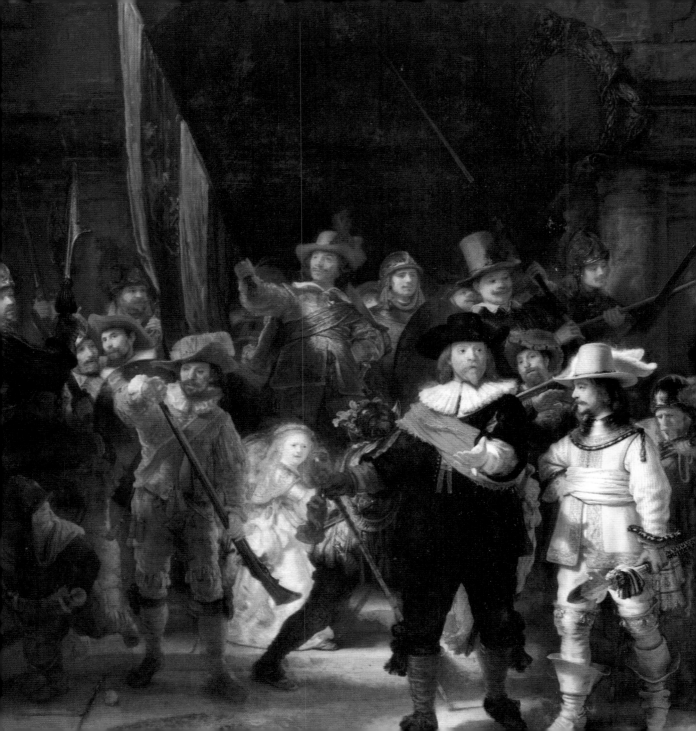

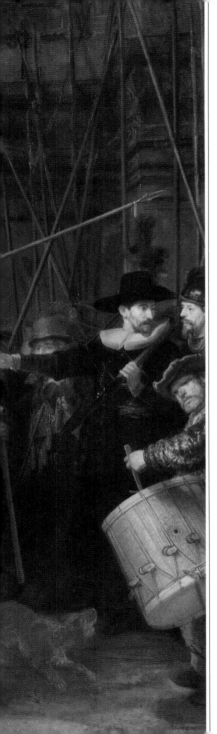

◁ The Night Watch 1642

Oil on canvas

THIS, THE MOST FAMOUS of all Rembrandt works, has been known as *The Night Watch* for the last two hundred years. A modern cleaning revealed that it is a daytime street scene, but the title has become too well-established to change. The picture shows the local militia company marching out under the leadership of Captain Frans Banning Cocq (in black). A few decades earlier, the militia companies had been important volunteer forces which helped to defend the Netherlands against the threat of a Spanish invasion; but by now they had become clubs for solid citizens, as the picture's general air of flag-waving, musket-priming and drumming indicates. *The Night Watch* is a group portrait, paid for by contributions from all the militia members shown; but Rembrandt has dramatized it by putting in non-paying bystanders so that it has become a colourful, confused scene of mustering on the street. The painting has been cut down, especially on the left-hand side, slightly unbalancing the composition.

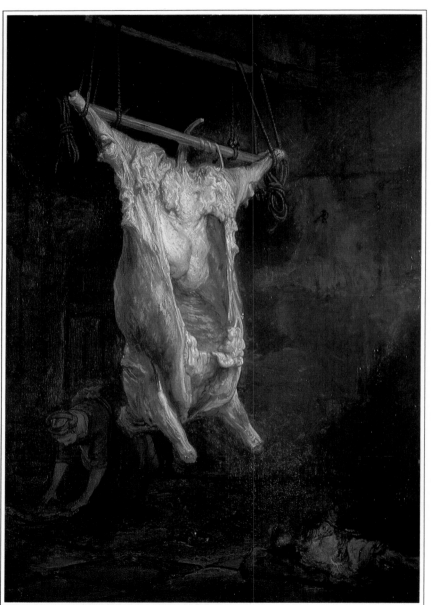

◁ **The Slaughtered Ox** c.1643

Oil on panel

STILL LIFE WAS A GENRE that Dutch artists made very much their own; it appealed to the downright realism that buyers liked, although in some examples the objects portrayed have a symbolic significance, carrying hidden messages such as *memento mori* (remember death will come). Rembrandt painted only a handful of still lifes, and here he has chosen to create a 'portrait' of a carcass. He (or some unknown client) was sufficiently interested in the subject to repeat the exercise a dozen years later, painting the larger version now in the Louvre. The one shown here is not a pure still life, although the woman working in the background is very unobtrusive. Our attention is fixed, with repelled fascination, on the raw flesh. Rembrandt seems to have executed this with conscious pleasure in his sheer skill, much as in the case of the *Anatomy Lessons* (pages 10 and 52).

▷ **Christ and the Woman Taken in Adultery** 1644

Oil on panel

THIS SPECTACULAR PICTURE has very much the air of a set-piece, perhaps painted on request for a wealthy patron. Its central group is certainly highly finished and detailed in a manner that Rembrandt was moving away from in the 1640s. The rich, red-and-gold, theatrical setting has the splendour of a baroque palace. It in fact represents the Temple in Jerusalem, and the episode is one in which the Scribes and Pharisees brought before Jesus a woman who had been caught committing adultery. Hoping to trap Jesus, his enemies enquired whether or not she should be stoned to death as the Law of Moses laid down. Jesus answered, 'He that is without sin among you, let him cast the first stone.' Shamed, the woman's accusers slipped away, and Jesus told the woman herself to go away and sin no more. Rembrandt's painting is one of dramatic contrasts – the brown-clad simplicity of Christ and his followers, the shame and glamour of the woman, and the rich apparel and palatial headquarters of the Scribes and Pharisees.

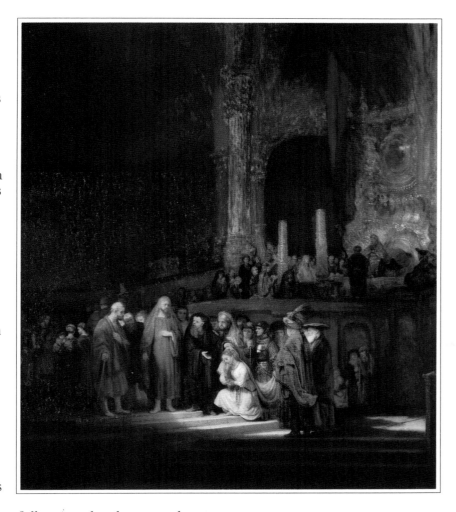

▷ **Girl Leaning on a Windowsill** 1645

Oil on canvas

THIS HAS TRADITIONALLY been called *Girl Leaning on a Windowsill,* although the painting is clearly a studio work and the 'windowsill' is a ledge or pedestal. However, nothing can detract from the charm of this apparently simple picture of a young girl, which has long been a great popular favourite. Rembrandt has painted her with a freedom which makes this very different from his usually meticulous public commissions, achieving a sense of inwardness that would become increasingly characteristic of his work. The girl's expression is particularly fascinating, seeming to change slightly (is she or is she not smiling?) even as the spectator looks at her. She has

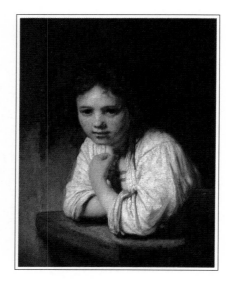

sometimes been identified as Rembrandt's housekeeper and mistress, Hendrickje Stoffels, although Hendrickje is not thought to have been in Rembrandt's service before about 1647. The possibility cannot be dismissed, despite the fact that this girl hardly looks like a nineteen-year-old.

▷ **The Holy Family with Angels** 1645

Oil on canvas

A WONDERFULLY TENDER painting that exemplifies Rembrandt's gift for blending the human and the divine so that it is impossible to distinguish one from the other. Here, Mary has paused in her reading to raise or adjust a cover, perhaps to shield the baby's face from the very concentration of light which signals his importance. Her attitude is the familiar one of the mother who checks on her child just to see that he or she is all right, for no particular reason, and is suffused with tenderness. The baby slumbers on in his wicker cradle with the total unconsciousness of the infant. In the background, Mary's carpenter husband Joseph gets on with his work. Mother, child and cradle are all Dutch 17th-century types, and this might almost be any family but for the descending angels, themselves represented as small children rather than adults.

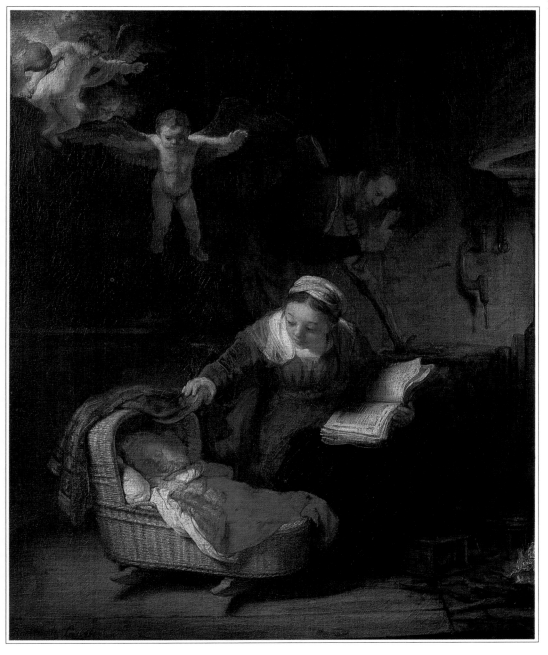

▷ **Winter Landscape** 1646

Oil on panel

REMBRANDT OCCASIONALLY painted landscapes over a period of some twenty years, but seems to have given up after 1654; from what we know of his business dealings, the reason seems to have been a straightforward lack of demand. He also made many drawings and etchings which are particularly admired. Of all Rembrandt's paintings in this genre, *Winter Landscape* has the freshest, most open-air feeling; but this does not mean that it was painted on the spot, a practice that only became acceptable in the 19th century. Preparatory drawings might be made in the open air, but a painting was worked up and given a high finish in the studio. This one may well be no more than a preparatory oil sketch, for it is very small and painted with remarkably free, broad brushstrokes – which is just what gives it the immediacy so congenial to modern taste.

▷ **The Adoration of the Shepherds** 1646

Oil on canvas

IN THE STABLE at Bethlehem, shepherds and other humble folk crowd round the baby Jesus in his crib. The light from the lantern carried by one of the visitors is feeble by comparison with the supernatural radiance emanating from the child, like the glow of a fire from which the others are taking warmth. The height of the dim-lit room adds to the sense of occasion, while the lines of the timbers give the composition much of its structural strength. These are ordinary people transfigured by what they have seen; the event is one that concerns all present, down to the child and his dog and even the cattle in their stall. This painting is one of many studies of the birth and infancy of Jesus made by Rembrandt in the 1640s, when he seems to have been particularly preoccupied by the subject.

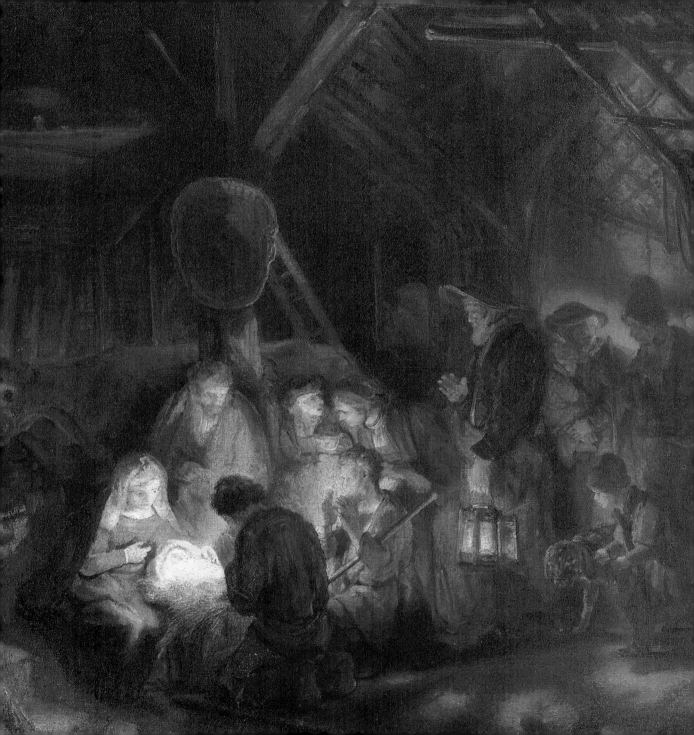

▷ **Susanna Surprised by the Elders** 1647

Oil on panel

THE STORY OF SUSANNA comes from the Apocrypha, a collection of Biblical writings whose authenticity has long been in dispute. However, this has not deterred Catholic or Protestant painters from tackling a subject with both dramatic and erotic appeal. As Susanna prepares to bathe in her garden, two Elders – pillars of the community – emerge from hiding and try to persuade her to lie with them, threatening that if she will not consent they will bear false witness that she has committed adultery with another man. Susanna refuses and the Elders secure her condemnation, but she is saved by the intervention of the prophet Daniel. Rembrandt's painting was begun in the mid-1630s but not completed and sold until 1647. Susanna, vainly attempting to cover herself up, looks exasperated rather than afraid, but the man plucking at her shift is a masterly study in lechery. Discarded slippers seem to have been potent erotic symbols in 17th-century Dutch art.

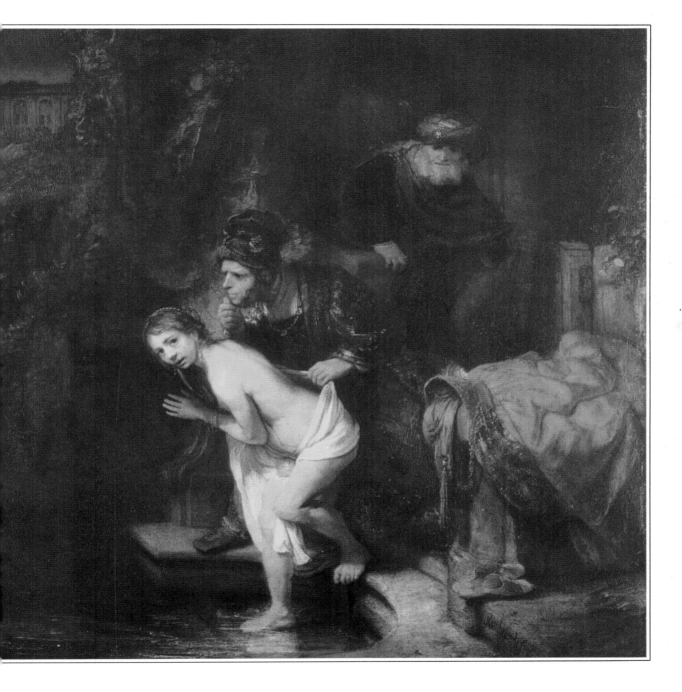

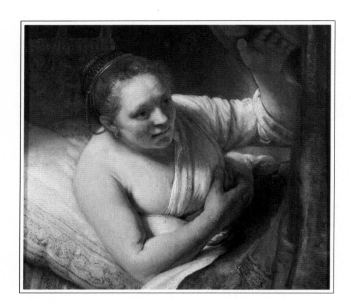

△ **Young Woman in Bed** 1647

Oil on canvas

HOLDING THE CURTAIN of her bed open with one hand and looking out expectantly, this woman is probably waiting for a bridegroom or lover; the composition may well have been suggested by *Sarah Waiting for her Bridegroom,* a painting by Pieter Lastman, the teacher from whom Rembrandt seems to have learned most. It is even more instructive to compare *Young Woman in Bed* with *Danaë* (page 27), which was as close as Rembrandt ever came to painting a smooth, lovely classical nude in the Italian style. Here he has returned to truth-to-life: where Danaë is glamorous and sexually confident, this woman is a homely creature, with her large, work-worn hands prominently displayed; and her attitude seems more like one of apprehension than invitation.

▷ **Christ at Emmaus** 1648

Oil on panel

ONE OF REMBRANDT'S favourite subjects, based on an episode in the Gospel According to St Luke. This tells how, after the crucifixion, two of Jesus's followers were on their way to the village of Emmaus, not far from Jerusalem. They fell in with a stranger who expounded Scripture to them, and sat down at a table with him for a meal. When he broke bread and handed some to each of them, 'their eyes were opened' and they recognized the stranger as Jesus, risen from the dead, whereupon he vanished. In an earlier version (c.1629) Rembrandt had treated the moment of revelation dramatically, with Jesus in silhouette and the men stunned as if by a thunderbolt. Here, the natural, human quality of the scene is emphasized; only the faint light playing round Jesus's head and his rapt expression indicate the presence of divinity – apparently unnoticed by the serving lad.

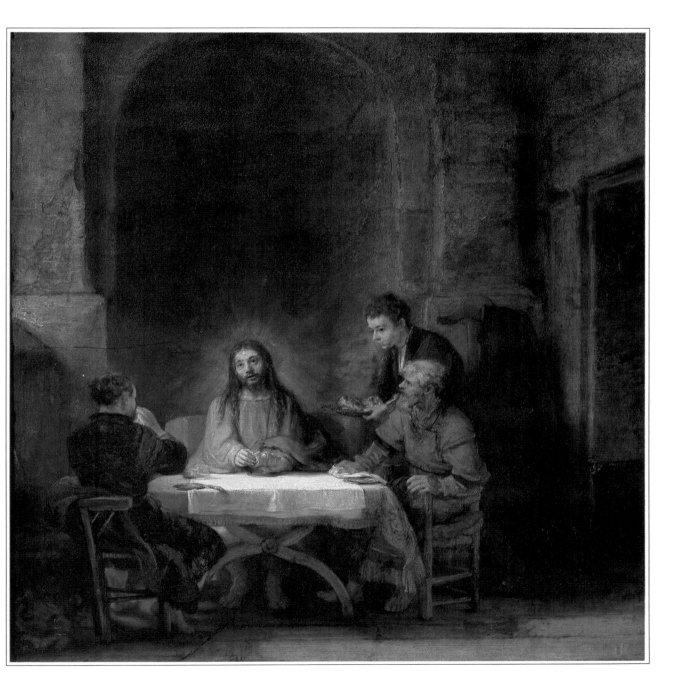

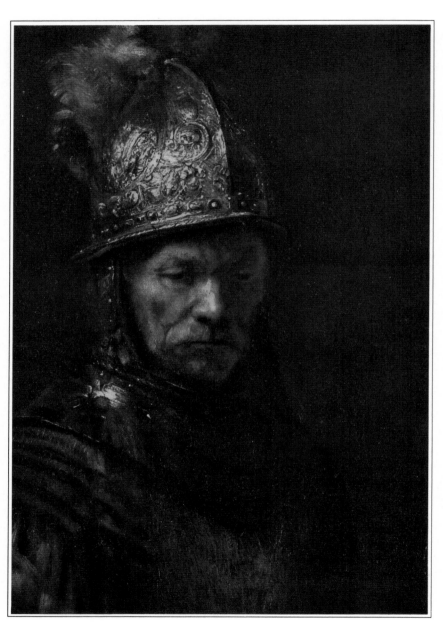

◁ **The Man with the Golden Helmet** c.1650

Oil on canvas

THIS MARTIAL FIGURE has no history attached to it, yet it has always been popular. One feature that helps to account for its fascination is the contrast between the polished breastplate and beautifully wrought helmet (surely ornamental rather than made for combat), and the unflamboyant, pensive expression of the man. The contrast is common in Rembrandt's self-portraits, and perhaps it was this that gave rise to the belief that the man with the golden helmet was Rembrandt's brother! In reality, many authorities have doubted whether the painting was by Rembrandt at all, and their doubts were confirmed by the investigations of the Rembrandt Research Project, a scholarly venture funded by the Dutch government. *The Man with the Golden Helmet* was only one of the Project's many 'victims' – paintings reattributed to Rembrandt's pupils or followers.

▷ **Bathsheba Holding King David's Letter** 1654

Oil on canvas

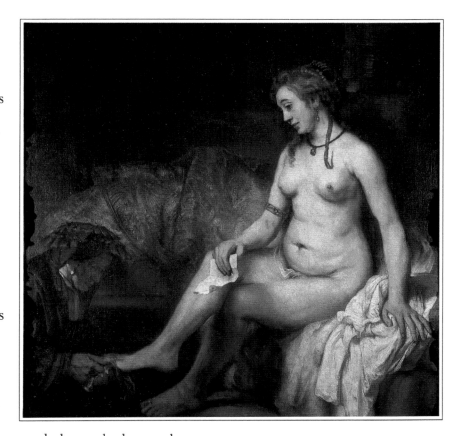

PAINTED WHEN REMBRANDT was at the very height of his powers; many experts look on this as the greatest of all his works. The commonly accepted interpretation is that the woman is the beautiful Bathsheba, whom the Biblical King David saw and lusted after. She gave in to him and conceived a child; and the subsequent complications culminated in what was effectively the murder of her husband by David. The story is an unsavoury one, and commentators have provided varying explanations of Bathsheba's emotions. As so often with Rembrandt, it is probably a mistake to try to be too specific, and it may be enough to say that the woman is reflecting gravely on her destiny. The composition is based closely on an engraving of an antique relief showing a bride being prepared for her marriage; Rembrandt has made her naked – surely a significant decision – and has created the very distinctive emotional tone. Bathsheba herself is probably Rembrandt's mistress, Hendrickje Stoffels.

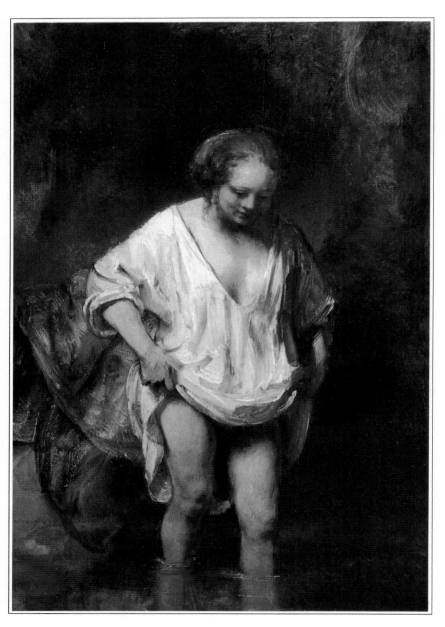

◁ **Woman Bathing in a Stream** 1654

Oil on panel

THIS PAINTING INEVITABLY invites comparison with *Bathsheba* (page 47), which was executed at about the same time and almost certainly portrays the same model, Hendrickje Stoffels. The bathing connection is also suggestive, extending to *Susanna* (page 42) as well; however, links of this sort may only mean that Rembrandt had a taste for such subjects or found them an excuse for pleasurable eroticism and bravura painting. Though the girl may or may not be a Biblical-historical character, she is not 'just a girl' to judge by the rich apparel piled up on the river bank. The picture seems to have been executed as a sketch, for it is painted in a rapid, cursory fashion that is apparent even in reproduction in the girl's limbs and, above all, her shift. But Rembrandt must have been proud of the work, since he signed and dated it.

▷ **Portrait of Jan Six** 1654

Oil on canvas

PERHAPS THE GREATEST of all
Rembrandt's portraits, this
combines accuracy and insight
in the most remarkable
fashion. While some parts of
the canvas are meticulously
painted (for example Six's
face), in others the brushwork
is audaciously free. This is
notable in the buttons on Six's
coat and the gold embroidery
on his rich red cloak, but the
eye is irresistibly drawn to his
hands, energized by vigorous
brushstrokes so that his
pulling on of a glove is full of
movement. The rival focus of
attention is Six's face, which
rather contradicts his man-of-
the-world appearance through
its inward-looking quality. Six
wrote of the painting in his
commonplace book, 'Such a
face had I, Jan Six, who since
childhood have worshipped
the Muses.' Six did write verse
and collect works of art, but he
was also a wealthy, hard-
headed businessman.
Rembrandt did a good deal of
work for him until the mid-
1650s.

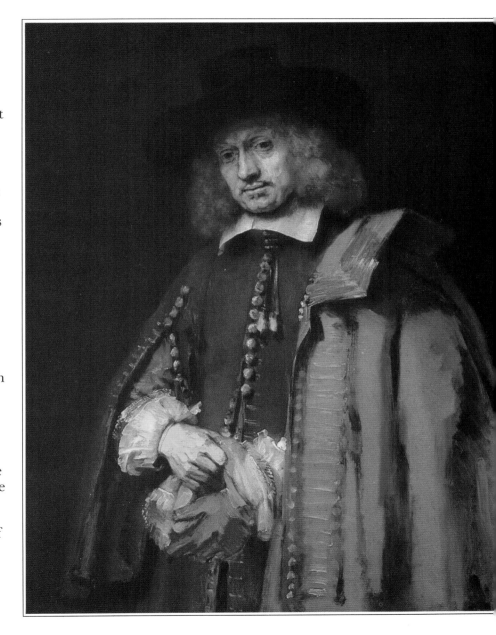

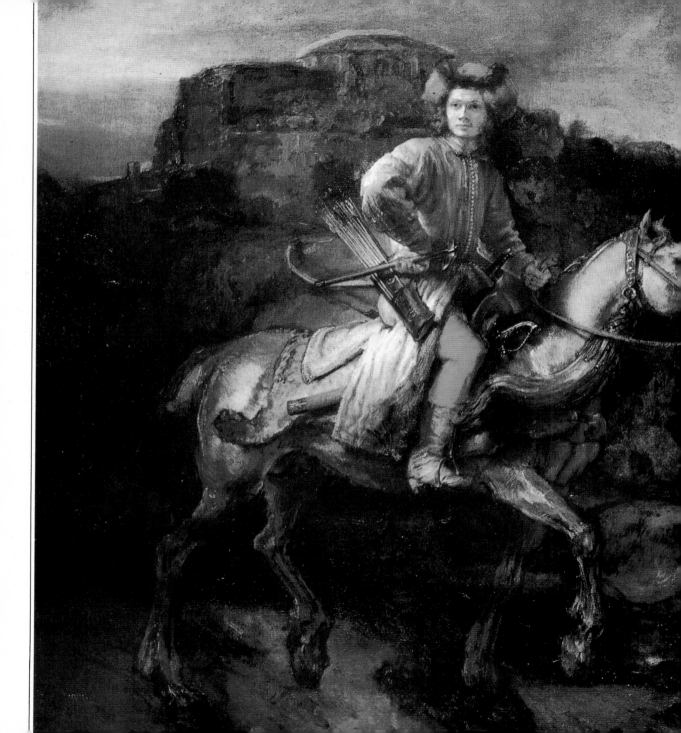

◁ **The Polish Rider** c.1655-7

Oil on canvas

THE MYSTERIOUS, romantic figure of this young man on horseback has generated more speculation than almost any other painting by Rembrandt – whose questionable authorship is just one more of the uncertainties surrounding it. The rider's fur hat and long coat look East European; but it is possible that we are simply viewing a theatrical scene or one of Rembrandt's excursions into fancy dress. If so, the Polishness of the picture has more to do with its later ownership by Poles than with its subject. On the other hand, there is the intriguing fact that in 1654 a pamphlet entitled *The Polish Rider* was published in Amsterdam, defending the radical Socinian sect; and there are many signs that Rembrandt was inclined to sympathize with religious dissent . . .Yet another problem concerns the rather unconvincingly portrayed horse. One solution is to reattribute the painting to a Rembrandt pupil such as William Drost. This is what the Rembrandt Research Project has done (see page 46); but its findings created intense controversy, and in 1993 the Project itself broke up.

▷ The Anatomy Lesson of Dr Deyman 1656

Oil on canvas

THE PAINTING WE NOW SEE is only about a quarter the size of the original, which was badly damaged by fire in 1723. As a result, Dr John Deyman stands, headless, behind the corpse, while his assistant occupies a position of fortuitous importance, holding the top of the skull; the other spectators, who would all have paid Rembrandt for their places, have disappeared. Dr Deyman succeeded to Nicholas Tulp's lectureship, and this celebratory group portrait fulfilled the same purpose as Rembrandt's earlier *Anatomy Lesson* (page 10). Deyman's lectures were given in January 1656. On this occasion Rembrandt has shown the scene more accurately than in the Tulp painting, since the stomach has been opened first and the contents removed. Deyman is actually demonstrating the structure of the brain, which dangles down the sides of the dead man's face like a shock of hair. The foreshortening of the feet is a notable visual device, although it would have been less conspicuous in the larger original. Despite this very important commission, Rembrandt went bankrupt in 1656.

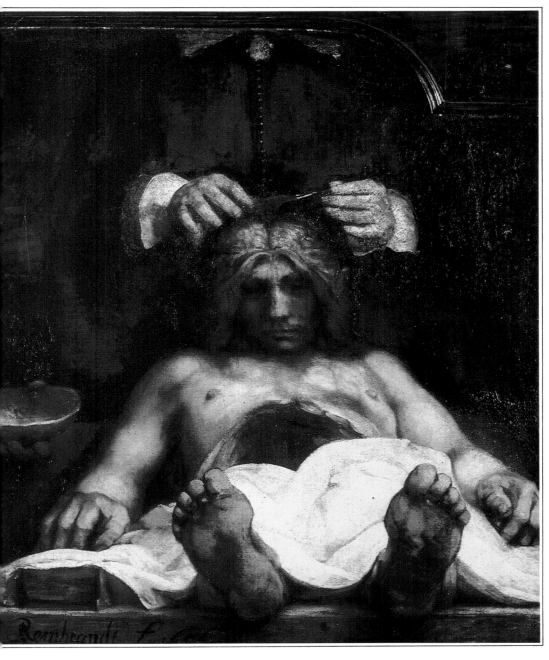

△ **Titus Reading** c.1656

Oil on canvas

TITUS, BORN IN 1641, was the only one of Rembrandt's children by Saskia van Uylenburgh to survive infancy. In this painting he is only about fifteen, but all Rembrandt's affectionate portraits of his son suggest a boy of amiable, gentle temperament. He played an important role in Rembrandt's life, both as the heir to Saskia's fortune (of which Rembrandt had temporary use) and as an agent for his father. In 1660 Titus and Rembrandt's mistress, Hendrickje Stoffels, formed a company that theoretically employed Rembrandt, the object being to ensure that the artist's earnings bypassed his creditors. After Hendrickje's death, Titus continued to act for his father. In 1665 he came of age and if he exercised his legal right to take control of Saskia's money, he must have become the financial head of the household. He married in February 1668 but died seven months later, aged only twenty-six.

▷ **Jacob Blessing the Sons of Joseph** 1656

Oil on canvas

THIS LARGE PAINTING now impresses as an exquisitely tender deathbed farewell. But the Biblical episode it depicts is more complicated than that. The Hebrew patriarch Jacob, old and blind, is blessing the children of his successful son Joseph, who has risen to become the chief adviser to the pharaoh of Egypt. But, contrary to custom, he is bestowing his chief blessing on the younger, Ephraim, answering his son's protests by declaring that Ephraim would become the greater, since 'his seed shall become a multitude of nations'. The episode had long been interpreted to mean that Ephraim would become the ancestor of the Christian nations, and Rembrandt appears to follow this tradition by making Ephraim fair and surrounding his head with an aureole. Characteristically, Rembrandt has avoided the element of conflict in the story.

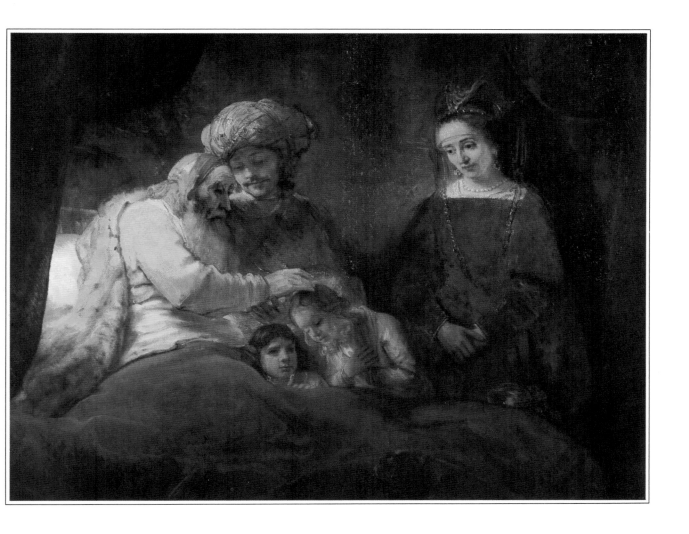

Detail

▷ **Portrait of Catrina Hooghsaet** 1657

Oil on canvas

PAINTED IN THE DISASTROUS YEAR when Rembrandt's personal effects were sold at auction, this superb portrait is a throwback to the artist's earlier, highly finished portrait manner of the 1630s. A comparison with the *Portrait of Jan Six* (page 49) reveals the contrasted strengths of two widely different techniques, each of which Rembrandt handled with complete mastery. Catrina Hooghsaet, a woman of fifty, was the wife of a dyer. Probably more to the point, she was a member of the Mennonite sect, with which Rembrandt had so many connections that it seems almost certain he was deeply interested in their doctrines; less rigid and censorious than the dominant Calvinists, they followed a lifestyle and held beliefs similar to those of the Quakers. However, there can never have been any serious question of Rembrandt – a man 'living in sin' with his housekeeper – joining the sect. But, whether because of her beliefs or her personality, Catrina Hooghsaet has a serenity rare among Rembrandt's more wealthy and respectable portrait subjects.

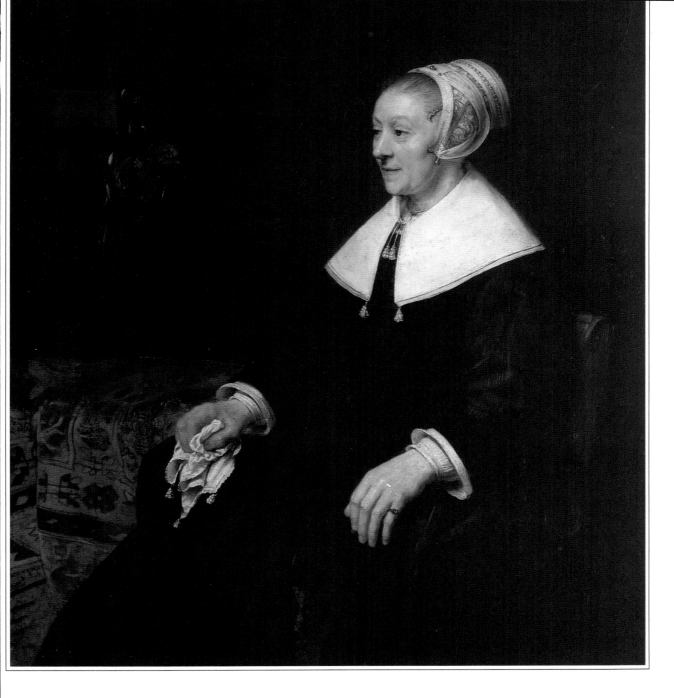

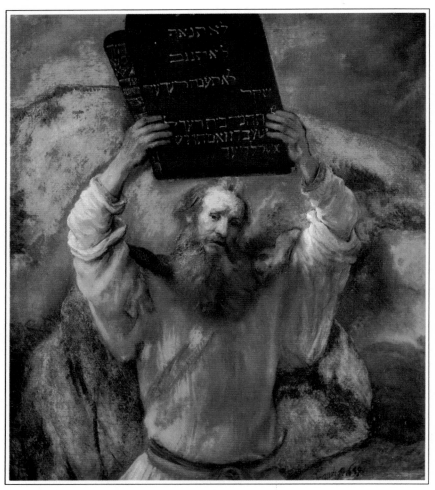

◁ **Moses with the Tablets of the Law** 1659

Oil on canvas

MOSES, ISRAEL'S LAWGIVER, has just come down from Mount Sinai with the two 'tables of stone, written with the finger of God' which carry the Ten Commandments. This is clearly a solemn event, but it is hard to be sure whether we are witnessing a triumph or the moment of rage in which Moses, seeing the Israelites idolatrously worshipping the Golden Calf, dashed down the tablets and broke them in pieces. On the other hand, this could be the second occasion on which Moses brought down the tablets, after purging the Israelites of their idolatry. The picture may have been executed for the mantelpiece of an Amsterdam alderman, possibly as an equivalent to the Moses-figure in Amsterdam town hall.

▷ **Jacob Wrestling with the Angel** c.1659

Oil on canvas

ATTEMPTS HAVE BEEN MADE to link this with *Moses with the Tablets of the Law* (page 58), possibly as two sections of a larger painting for the Amsterdam municipality; but no entirely convincing case has yet been made. The picture here has certainly been cut down, so originally the grappling figures would not have filled up the available space so completely. Their struggle is described in one of the more enigmatic passages of the Old Testament. While the Hebrew patriarch Jacob is alone, a man – traditionally an angel – appears and wrestles with him all night. When he fails to break Jacob's resistance, the angel touches the hollow of his thigh and puts it out of joint. Nevertheless Jacob has in some way passed a test and receives the new name Israel, signifying that he has prevailed over both God and men. In a sense, then, the almost lover-like postures of Jacob and the angel in this painting have a certain appropriateness.

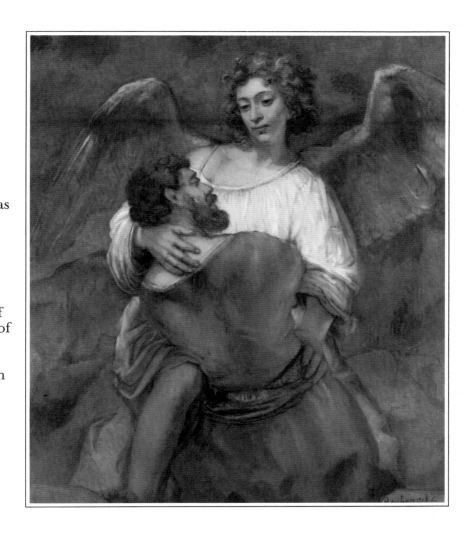

▷ **Ahasuerus and Haman at the Feast of Esther** 1660

Oil on canvas

THIS SHOWS THE CLIMACTIC moment in the Biblical story of Esther, a Jewish woman who is said to have become the consort of the Persian king Ahasuerus (actually Xerxes, 486-465 BC). The king's chief adviser, Haman, ignorant of Esther's background, has plotted to hang her foster-father Mordecai and have all the Jews in the Persian empire put to death. Haman's schemes have already partly miscarried; now, apparently honoured by Esther's invitation to dine with her and the king, he is about to be denounced and hanged on the gallows he has prepared for Mordecai. Rembrandt has lit the scene with dramatic symbolism, with the hero and heroine in the spotlight and the villain in shadow – theatrical terminology that may not be misplaced, since there is compelling evidence to indicate that Rembrandt's painting represents a scene from an Esther play that was popular in Amsterdam at this very time.

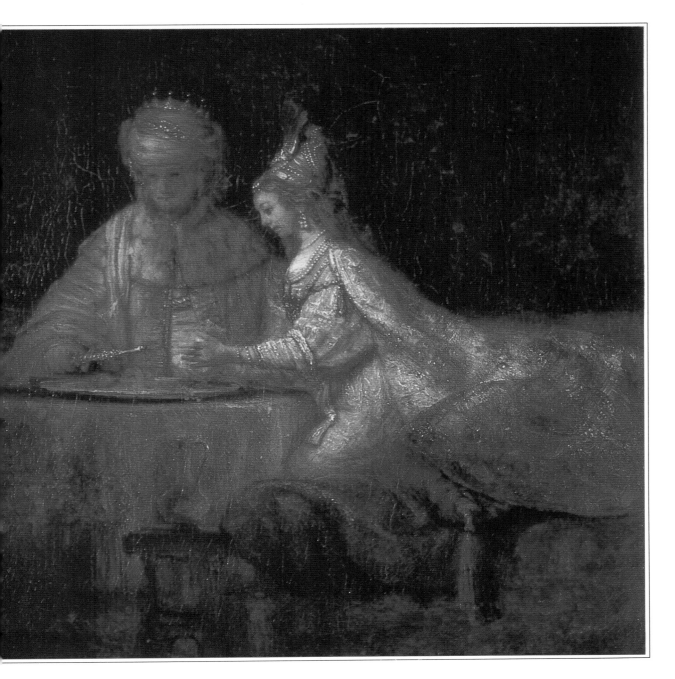

▷ **David Sending Away Uriah** c.1660

Oil on canvas

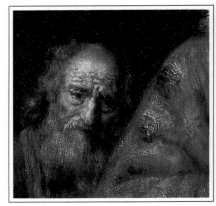

Detail

NEITHER THE EXACT DATE nor the subject of this lovely, atmospheric painting are known, and this fact has given rise to much speculation. One plausible interpretation relates it to *Ahasuerus and Haman at the Feast of Esther* (page 60), describing it as Haman's downfall, or else as the moment when Haman secures the king's permission to have the Jews done to death. The argument is reinforced by identifying both this painting and The Feast of Esther as scenes from a play staged in 1659, rather than as episodes from the play's Biblical source. There is certainly something theatrical about Rembrandt's painting but, in addition to discrepancies of detail, the proposed subjects do not chime very well with the quiet, sad mood of the painting. On these grounds there is a case for reviving an older theory, that the figure in red is Uriah, husband of the Bathsheba whom King David has seduced (page 47), being sent away by a guiltily uneasy king.

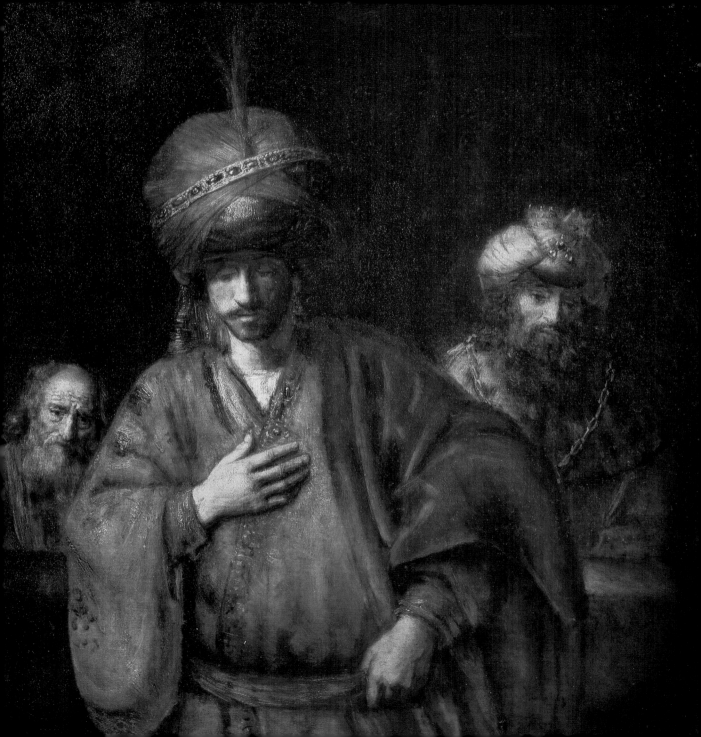

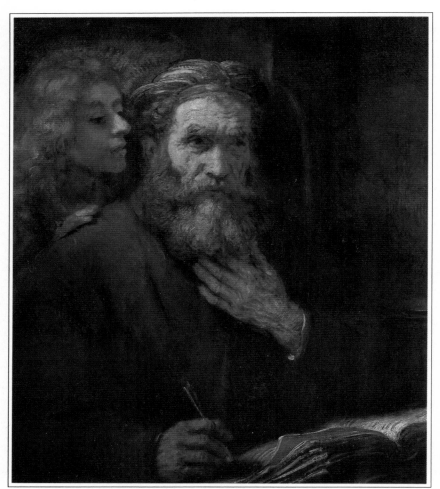

◁ **St Matthew and the Angel** 1661

Oil on canvas

THIS IS ONE OF A GROUP of imaginary portraits of apostles, painted by Rembrandt at about this time. Unlike the others, St Matthew and the Angel has more than one figure, since the angel is placed directly behind the apostle, inspiring the writing of his Gospel. The angel bears a close resemblance to Rembrandt's son Titus, who may well have served as the model, but the apostle is certainly not Rembrandt. Apart from its religious meaning, the painting gives an insight into the contrasts between youth and age, though the usual roles are reversed. The angelic youth is calmly certain of himself and comforting, with his hand on the older man's shoulder. St Matthew is pondering, plucking his beard with hands veined with age. His book, though scarcely an accurate representation of a Biblical scroll, is a splendid piece of painting.

▷ **Simeon with the Christ Child in the Temple** c.1661

Oil on canvas

THOUGH IT WAS a commissioned work, begun in 1661, this painting lay unfinished in Rembrandt's studio at his death in 1669. The subject is the fulfilment of a prophecy. The aged Simeon had been promised that he would not die without seeing the Messiah. This happened when Joseph and Mary brought Jesus to the Temple to be presented to the Lord. Rembrandt had already painted a splendid formal version of this subject (1631), set in the lofty interior of the Temple and executed in the accomplished manner of his fashionably successful young manhood. Here, the freer manner of Rembrandt's later years is accentuated by the unfinished state of the painting, but it hardly seems to matter; everything is concentrated on the intimate, infinitely tender moment when the purblind old man cradles the swaddled infant in his arms.

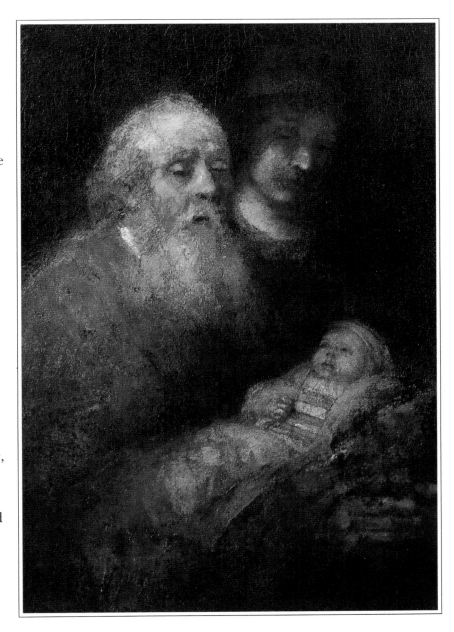

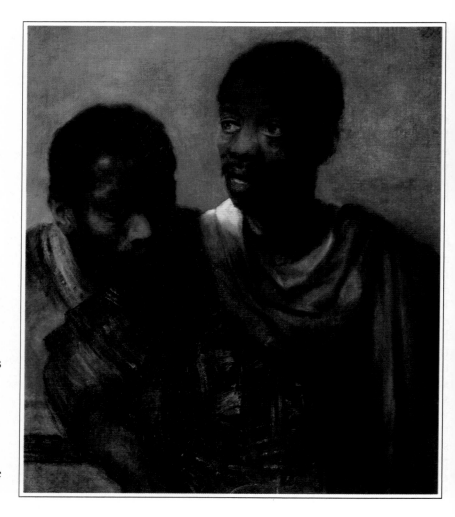

▷ **Two Africans** 1661

Oil on canvas

REMBRANDT LIVED in an apparently narrow world, never leaving his native Netherlands. But although the Netherlands was small, for much of the 17th century it was the leading commercial power in Europe, with colonies and trading posts from America to Indonesia. So Rembrandt's taste for the exotic – for turbans and quaint armour, and also for Indian miniature paintings – was not really surprising ; and since the interest seems to have been shared by many of his clients, we cannot assume that works inspired by them were unsaleable. What is more surprising is how few paintings of Africans were made by European artists, given the existence of the huge and horrible slave trade and the numbers of blacks imported as curiosities or servants; the main exceptions occurred in representations of the Adoration of the Kings, since one of the kings was traditionally supposed to be an African. Rembrandt's painting of these unidentified Africans is characteristically accurate and respectful of human dignity.

▷ **Self-portrait** c.1661-2

Oil on canvas

REMBRANDT WAS a compulsive
self-portraitist, yet he rarely
showed himself at work. In
fact, this picture was only the
second of his self-portraits in
which he is seen holding his
palette and brushes, and the
long maulstick which artists
use as a rest to steady their
painting hands. The light
background of the picture is
an unusual touch, no doubt
necessary if we are to see the
curved lines behind
Rembrandt on the wall. Many
explanations of their presence
have been offered; currently
the favoured theory is that
they link him with legendary
stories about great painters
such as Apelles and Giotto,
who are said to have identified
themselves or displayed their
skill by drawing a single
perfect line or circle. If this
explanation is correct,
Rembrandt's self-portrait is
asserting his claim to be
recognized as the master-
painter of his age.

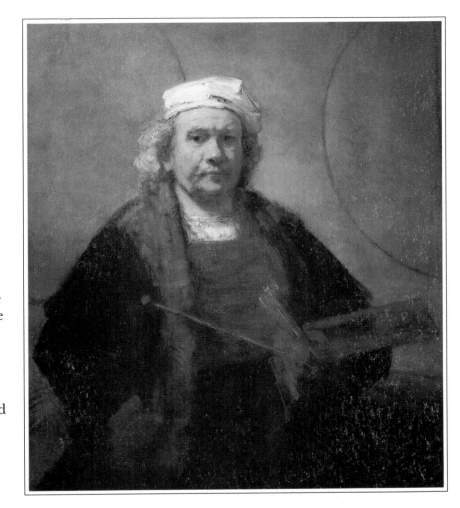

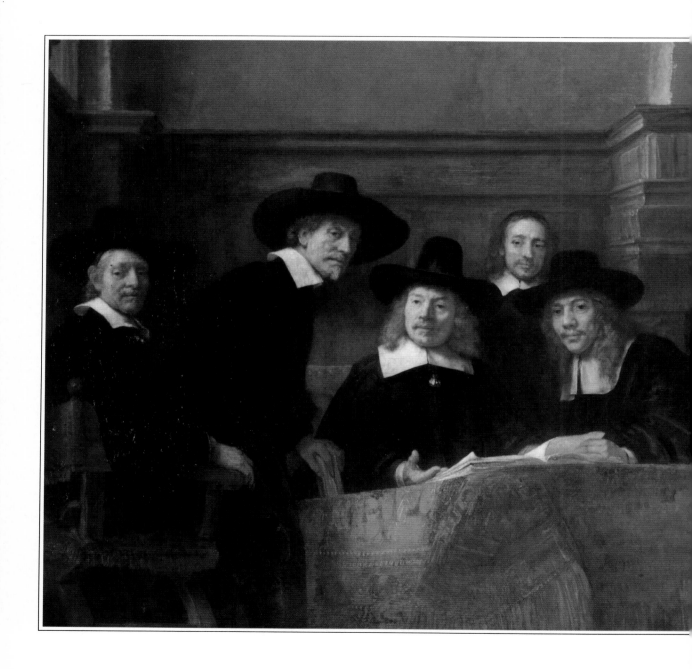

◁ **The Sampling Officials** 1662

Oil on canvas

THIS IS ALSO KNOWN as *The Syndics* or *Staalmeesters* (Samplemasters). All the titles refer to the office held by these members of the Drapers' Guild, charged to sample and inspect cloth as a form of quality control. The picture was Rembrandt's final group portrait with a distinctive mood of its own, created by the fact that the officials are looking straight at the spectator and from on high: the viewer gets the feeling that he or she might easily be subjected to a cross-examination and found guilty of something. In reality the low viewpoint was probably adopted because the picture was intended to hang above a mantelpiece in the Guild headquarters, along with earlier group portraits on the same lines. Traditionally such portraits showed the five officials seated, with an usher standing in attendance. Rembrandt has modified the tradition to give the composition variety and movement, picturing one man in the act of getting up, perhaps as a sign that the meeting is over.

▷ **The Jewish Bride** c.1662

Oil on canvas

The Jewish Bride is a traditional title, based on a 19th-century interpretation of the painting that has been abandoned. The woman is almost certainly neither a bride nor Jewish, except possibly in the make-believe Biblical fashion of Rembrandt's history paintings. Rembrandt did have contacts among Amsterdam's Jewish community, and his interest in drawing some of them led later scholars to make many unwarranted assumptions. Currently favoured explanations of the picture are that it represents a theatrical scene, or the Biblical episode in which the patriarch Isaac passed off his wife Rebecca as his sister while they dwelt among the Philistines, only daring to embrace her when they were alone together. What really matters, however, is that the couple obviously love each other profoundly. This is one of the glowing, red-and-gold masterpieces of Rembrandt's old age. The cloth is painted in places with slashing strokes of the palette or built up to an extraordinary, light-reflecting thickness; it is incomparably rich and yet somehow does not dominate but strengthens the human emotion of the scene.

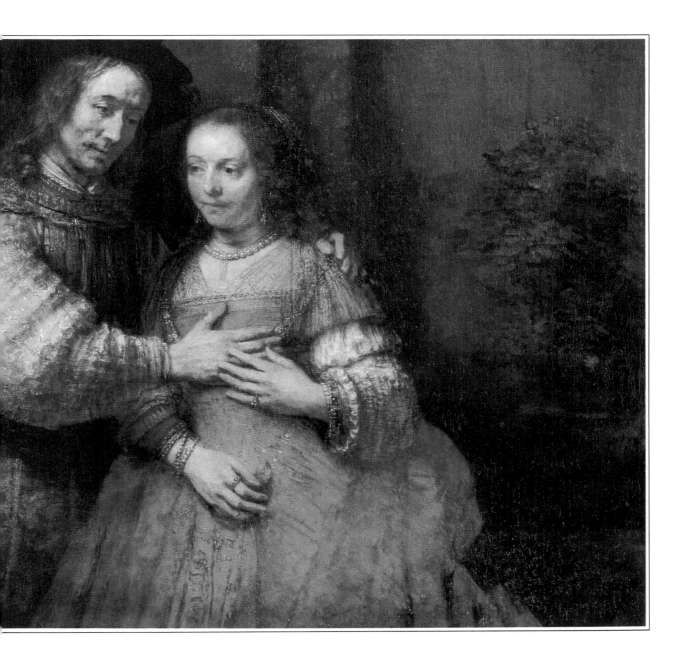

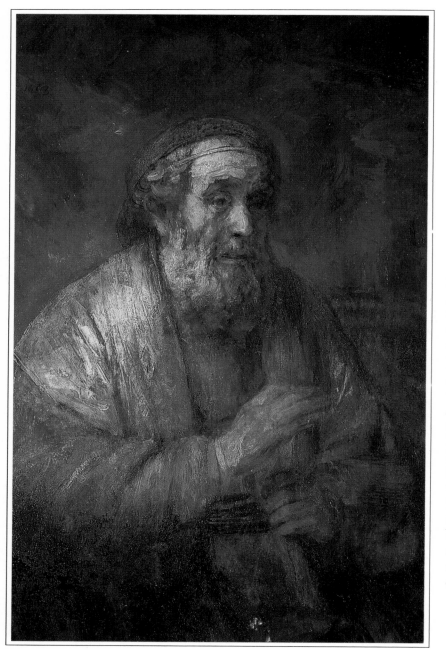

◁ **Homer** 1663

Oil on canvas

THIS IS WHAT SURVIVES of a much larger painting, damaged by fire at some point in its history and cut down to its present size. A drawing by Rembrandt which seems to be a preparatory sketch shows the poet dictating to a scribe, who would therefore have sat on the right-hand side of the picture. Homer, whose two epic poems, the *Iliad* and the *Odyssey*, stand at the very beginning of Greek literature;; was said to be blind, which is why he is shown as dictating. Rembrandt based his portrait of the poet on an antique bust which also appears in his *Aristotle Contemplating the Bust of Homer*, painted in 1653 for a Neapolitan patron, Antonio Ruffo of Messina. The same Ruffo ordered the Homer, which Rembrandt shipped, half-finished, to Messina for approval in 1661. Ruffo sent it back the following year, and after some haggling over money it was finished and dispatched in 1663!

▷ **Lucretia** 1666

Oil on canvas

THE SUICIDE OF LUCRETIA is part of an early Roman legend which explained the fall of the monarchy and the setting up of the republic. Lucretia, raped by a son of Tarquinius, king of Rome, told her husband of the outrage, urged him to revenge her, and then killed herself. The subject was often treated by artists and writers; late in the previous century, Shakespeare had written a long narrative poem, *The Rape of Lucrece,* before making his mark in the theatre. Rembrandt painted two pictures on the subject, in the earlier of which (1664) Lucretia is about to deal herself the fatal blow. Here she has just done so, as the spreading red stain on her fine linen garment reveals. She is still upright, momentarily supporting herself by clutching the bell-pull (also a useful device which enabled the model to keep her arm raised for long periods!) but her ghastly pallor suggests that the end is near.

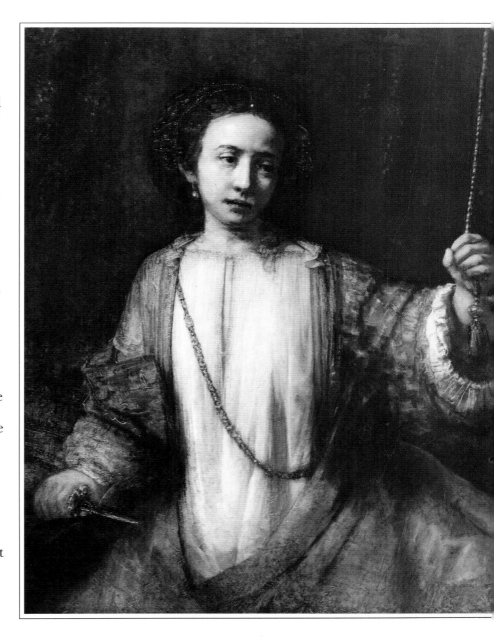

Detail

▷ **The Return of the Prodigal Son** c.1668

Oil on canvas

THIS IS PERHAPS Rembrandt's most purely sublime painting. The subject is taken from the New Testament parable in which Jesus tells of a son who insists on receiving his inheritance, spends it on wild living in a far country, and then sinks into destitution. When he summons the courage to return home, his father forgives him at once and receives him with joy. The religious meaning of the parable is that, however badly a person has sinned, repentance will always be rewarded with joyful forgiveness. Here Rembrandt seems to have concentrated on its human significance. The Prodigal's close-cropped head and ragged clothes tell their own story, especially since his collar preserves a suggestion of former luxury. His shoes are threadbare; one has dropped off as he kneels at his father's feet. The father responds, holding his son to his heart. Characteristically, Rembrandt avoids the element of conflict presented by the dutiful son's jealousy, though he may be present as a shadowy figure behind his father.

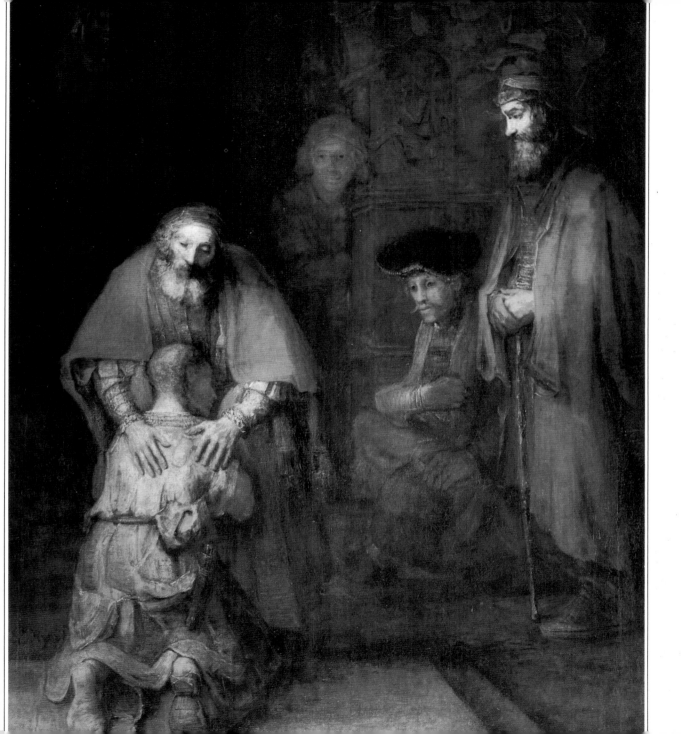

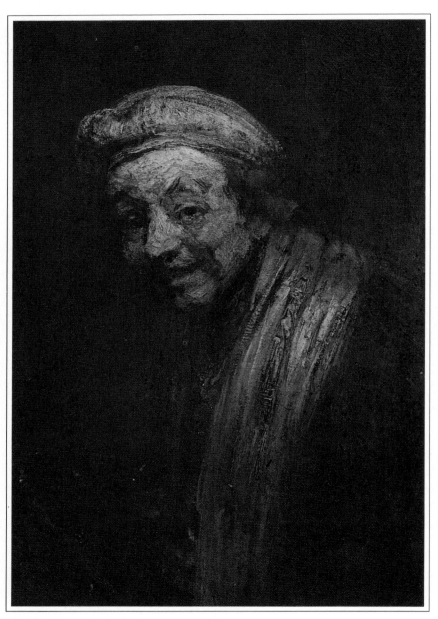

◁ **Self-portrait as Zeuxis** 1669

Oil on canvas

REMBRANDT PAINTED himself from various angles and in all sorts of guises. Sometimes he viewed himself with a sober eye, noting the effects of time on his livid and sagging features; but often he took on different identities, appearing in fancy dress as an armoured warrior, as a bulky, imposing monarch, and as the apostle St Paul. *Self-portrait as Zeuxis* has elements of both types. It shows an old man in an advanced state of decay (much more so than on page 77, painted in the same year), evidently close to death. But it is also a portrait of *Rembrandt as Zeuxis,* an ancient Greek artist who painted a wrinkled old woman and thought her appearance so ludicrous that he laughed himself to death. The common element in all this is, of course, death; so, if the picture is a joke of sorts, its humour is very black.

▷ **Self-portrait** 1669

Oil on canvas

LIKE THE *Self-portrait as Zeuxis,* this was painted in the last year of Rembrandt's life. But this time there is no suggestion of black humour or overt reference to the approach of death. This is perhaps the most completely resigned of all the self-portraits: the elderly artist, plainly dressed and with hands clasped, looks out at us without appeal or complaint. Whether the death of Titus in September 1668 hastened his father's end, we are never likely to know. At any rate, only thirteen months later, on 4 October 1669, the artist died in his house on the Rozengracht, aged only sixty-three. Four days later he was buried in a grave in the Westkerk, Amsterdam. The site of Rembrandt's grave is unknown; but his work will live on.

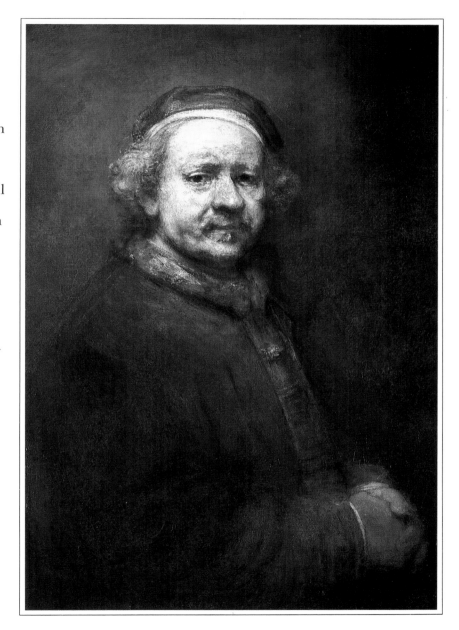

ACKNOWLEDGEMENTS

The Publisher would like to thank the following for their kind permission to reproduce the paintings in this book:

Archiv fur Kunst und Gershichte, Berlin /Mauritshuis, Den Haag 10-11; /**Rijksmuseum, Amsterdam** 32-33, 52-53, 68-69, 70-71;

Bridgeman Art Library, London /Chatsworth House, Derbyshire 24; /**Dahlem Staatliche Gemaldegalerie, Berlin** 42-43, 58; /**Dulwich Picture Gallery** 14, 36; /**Frick Collection, New York** 50-51; /**Gemaldegalerie, Berlin** 46; /**Gemaldegalerie, Kassel** 38-39, 55; /**Giraudon /Louvre, Paris** 15, 45, 47; /**Glasgow City Art Gallery and Museum** 34; /**Hermitage, St. Petersburg** 18, 19, 25, 27, 28-29, 37, 62, 63, 74, 75; /**Kenwood House, London** 67; /**Kunsthistorisches Museum, Vienna** 54; /**Louvre, Paris** 12-13, 64; /**Mauritshuis, The Hague** 66, 72; /**Minneanapolis Society of Fine Arts, Minnesota, USA** 73; /**National Gallery, London** 22-23, 35, 41, 48, 77; /**National Gallery of Scotland, Edinburgh** 44; /**National Gallery of Victoria, Melbourne** 8, 9; /**National Gallery of Wales, Cardiff** 57; /**National Museum, Stockholm** 65; /**Pinakothek, Munich** 31; /**Prado, Madrid** 20-21; /**Private Collection** 56; /**Private Collection, Amsterdam** 49; /**Pushkin Museum, Moscow** 17, 60-61; /**Staatliche Kunstsammlungen, Dresden** 26; /**Staatliche Museen zu Berlin** 59; /**Wallarf-Richartz Museum, Cologne** 76.